ANNELORE PAROT

T0024756

YOUR STEP-BY-STEP GUIDE

KAWAII!

TO CUTE JAPANESE DRAWING

Skittledog

CONTENTS

JAPAN, DRAWING, & ME

I've been teaching how-to-draw classes for many years and have also written several books on the subject. People often ask me to show them simple techniques for Japanese-themed drawings, showing its fascinating people, places, and objects.

When I visited Japan, I kept my eyes wide open, looking for the most memorable sights and making hundreds of drawings. In this book, I'll show you what I drew: people, places, and things. You'll find everything from food and drink to Japan's favorite animals, and even the mythological *yokai* spirits of the natural world. Along the way, you'll have the chance to experiment with the emotions, expressions, and movements that will bring your cute drawings to life.

I believe that everyone can draw. Some people find it a little tricky, often because they don't know where to start. To them, I say that drawing is a little like writing: you just make marks in the right order. So if you know how to write, you can draw too! All of the exercises in this book work in the same simple way: make a few marks with your pencil, and you can watch your picture come to life.

Time to get started! You can follow these tutorials in whatever order you like and, whether if you're in the mood for a calming kimono pattern, a happy little person, or a busy street scene, you'll find the right exercise for you. The most important thing is to have fun!

This is me—Annelore!

WHAT YOU'LL NEED

You don't need much equipment to get started.

Pencils to sketch your outlines
Pencils marked with an H have a firm lead for drawing faint lines. This is useful when you're first starting a drawing. Pencils marked with a B have a softer lead and are for drawing darker lines. This makes them handy for drawing over your initial sketch with a stronger line. HB pencils are in between the two. Whichever pencil you use, don't press too hard—you don't want to score the paper, or break the lead!

Colored pencils and felt-tip pens
Useful for coloring your drawings (obviously!) and creating patterns. Make sure that you use the lightest shades first, then move on to the darker or more intense hues. When you're using felt-tip pens, use a fine-tipped black pen for the outlines and broader tips to fill in areas of color.

Eraser and pencil sharpener

Sketchbook (or notebook, or journal)
You need somewhere to practice—once you've filled all the pages of this book!

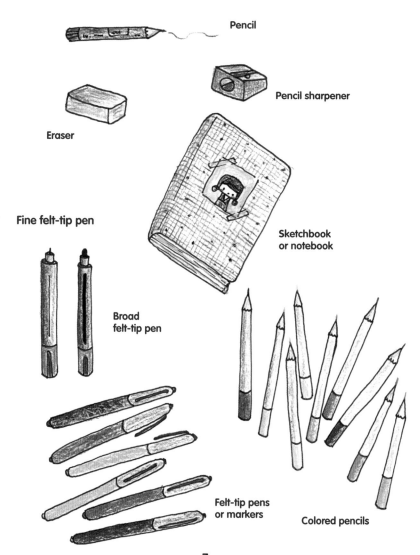

Pencil

Pencil sharpener

Eraser

Fine felt-tip pen

Broad
felt-tip pen

Sketchbook
or notebook

Felt-tip pens
or markers

Colored pencils

7

People

LITTLE GIRL

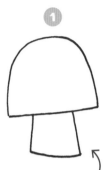

Start with a basic mushroom shape.

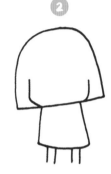

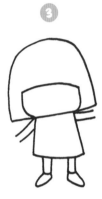

10

CREATE AND COLOR!

LITTLE BOY

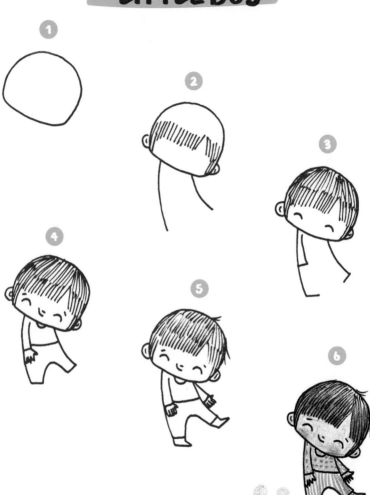

GET GOING!

GRANDFATHER

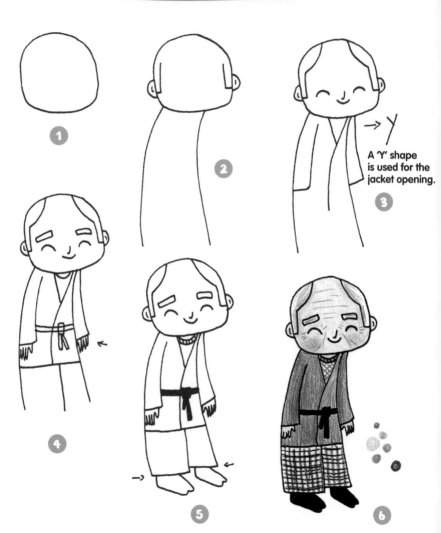

A 'Y' shape is used for the jacket opening.

14

NOW iT'S YOUR TURN!

GRANDMOTHER

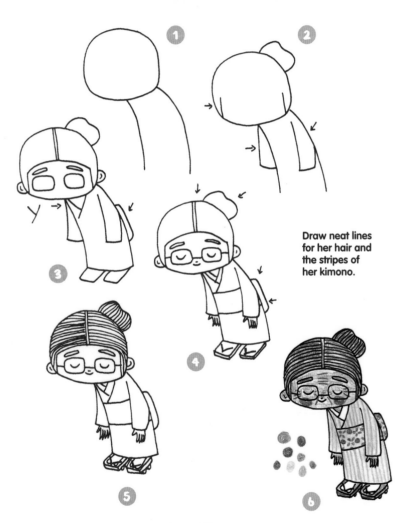

Draw neat lines for her hair and the stripes of her kimono.

OVER TO YOU!

YOUNG WOMAN

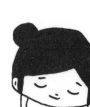

These construction lines will disappear when you color in the hairstyle.

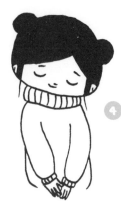

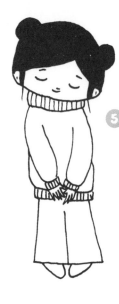

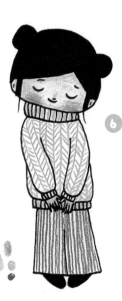

NOW YOU
DRAW HER!

BABY

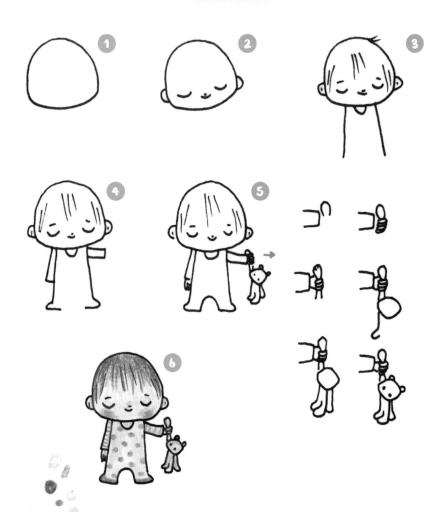

PENCIL TIME!

YOUNG MAN

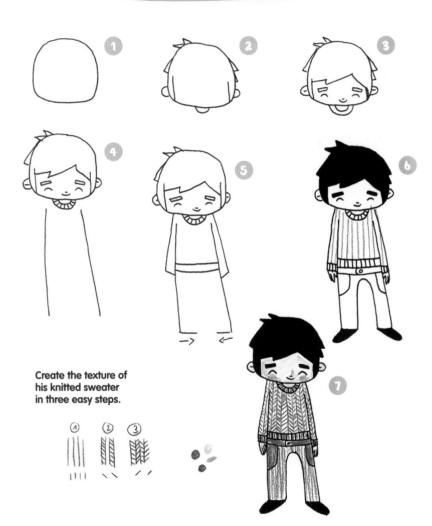

Create the texture of his knitted sweater in three easy steps.

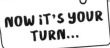

NOW iT'S YOUR TURN...

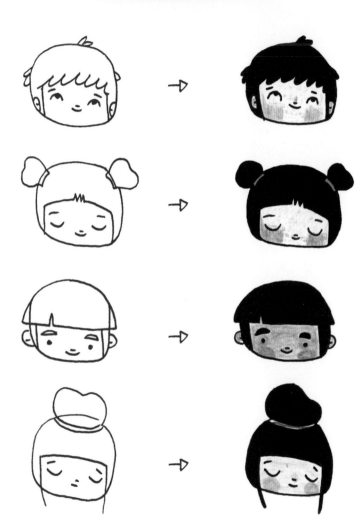

24

YOU TRY!

FACES 2

GIVE THEM
PERSONALITY

FACES 3

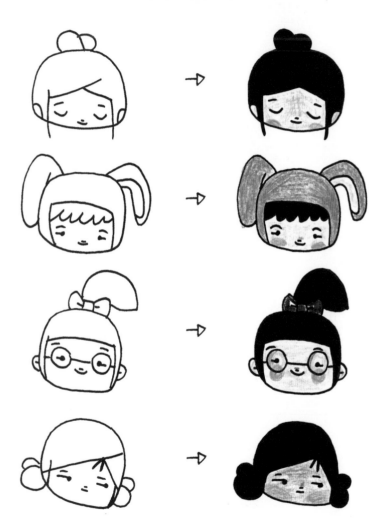

DRAW AND
COLOR!

FACES 4

 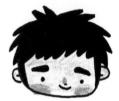

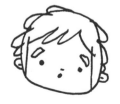

SKETCH TIME!

JOYFUL

BORED

ANGRY

SURPRISED

AFRAID

SAD

WORRIED

HAPPY

CHEEKY

DOUBTFUL

FURIOUS

CALM

WHAT MOOD
ARE YOU IN?

KIMONO GIRL

A kimono is a traditional Japanese robe with wide sleeves and a sash around the waist.

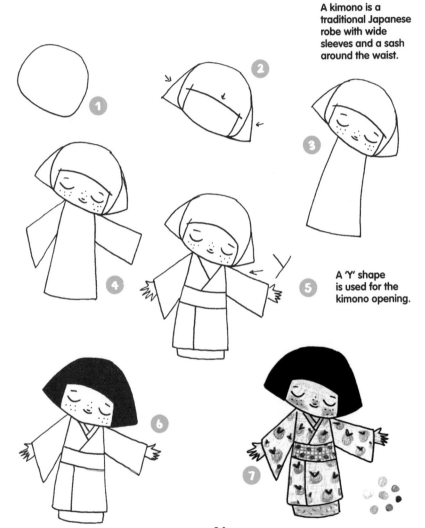

A 'Y' shape is used for the kimono opening.

34

YOUR TURN!

HAPPY BOY

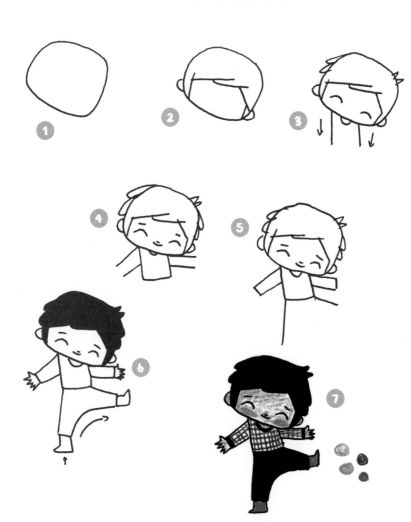

36

TiME TO PLAY!

DANCING GIRL

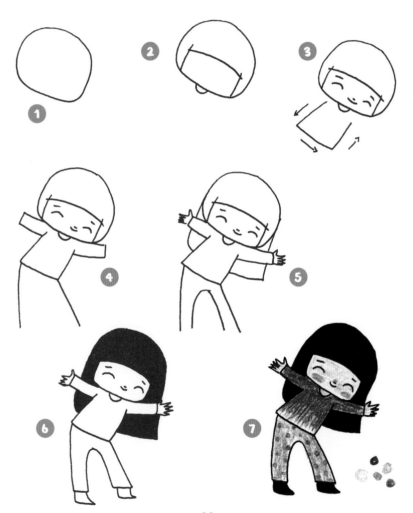

TRY FOR
YOURSELF...

HAPPY GIRL

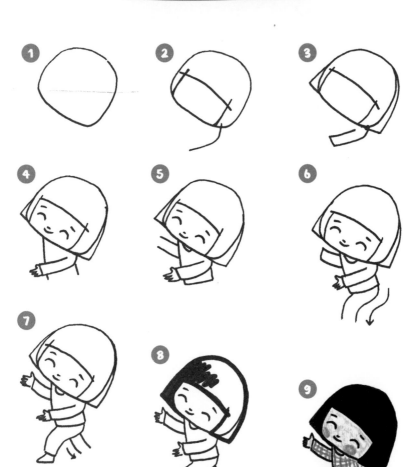

NOW...
DRAW!

WALKING WOMAN

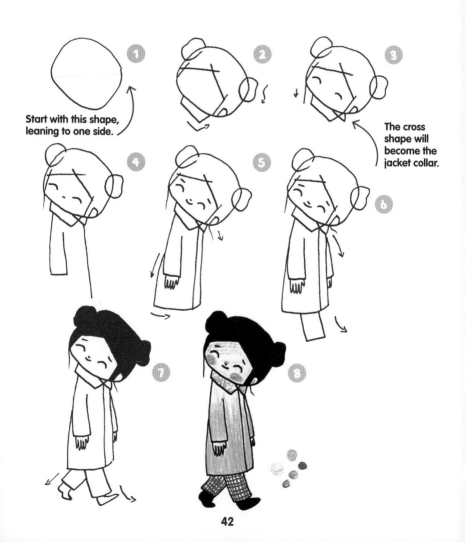

Start with this shape, leaning to one side.

The cross shape will become the jacket collar.

YOUR TURN!

WALKING MAN

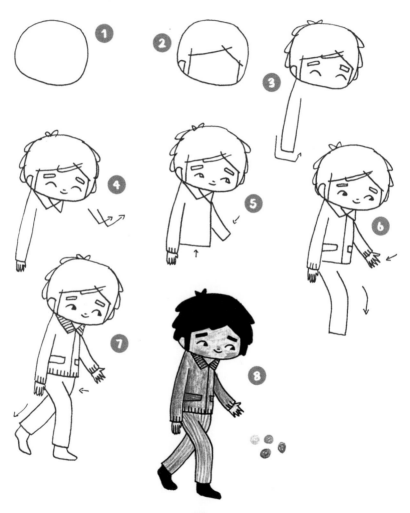

44

GET STARTED!

CHILD WITH CAT

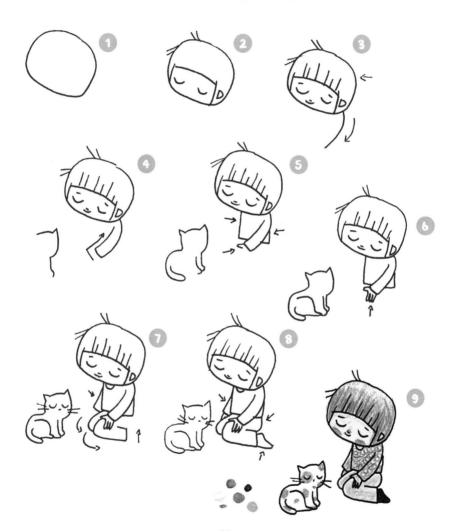

YOU TRY IT...

KIMONO WOMAN

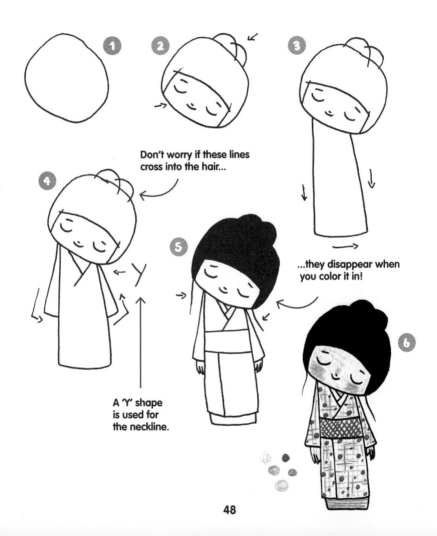

Don't worry if these lines cross into the hair...

...they disappear when you color it in!

A 'Y' shape is used for the neckline.

48

SUMO WRESTLER

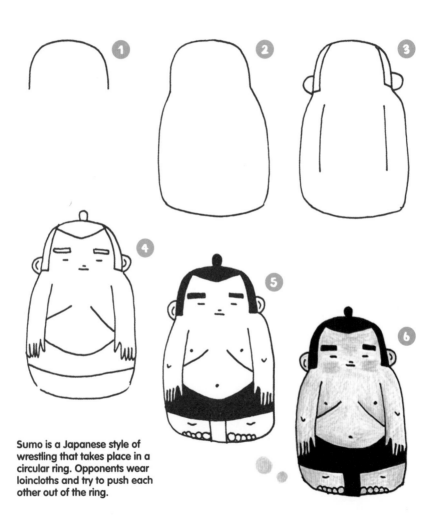

Sumo is a Japanese style of wrestling that takes place in a circular ring. Opponents wear loincloths and try to push each other out of the ring.

50

PENCILS OUT!

SCHOOLGIRL

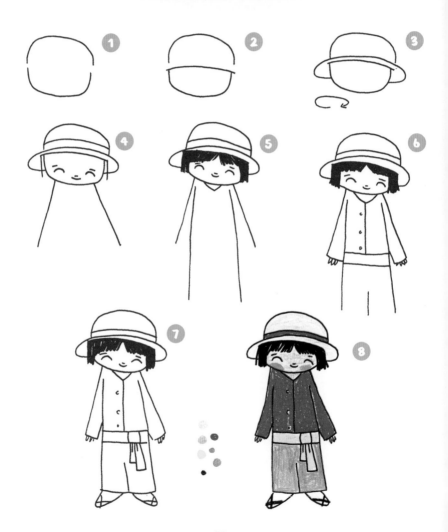

DRAW HER YOURSELF!

KiTTEN COSPLAY

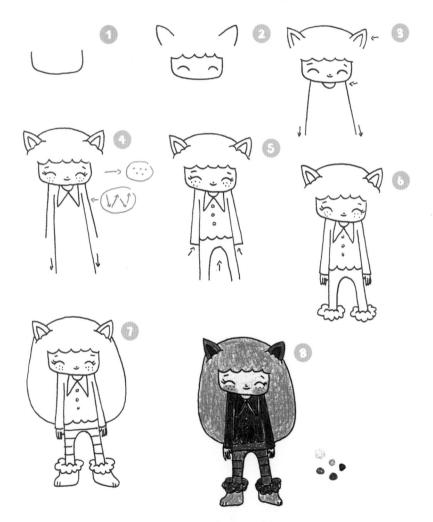

OFFICE WORKER

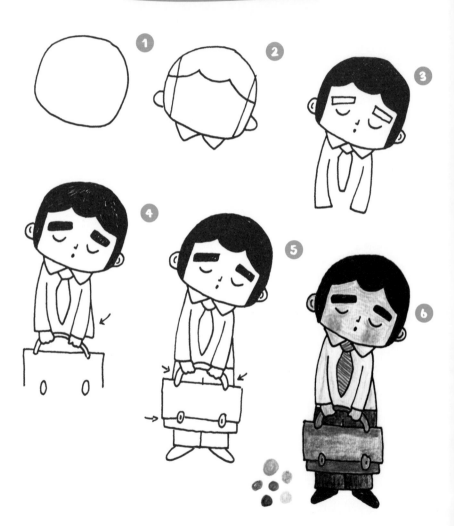

NOW YOU
TRY...

POLICE OFFICER

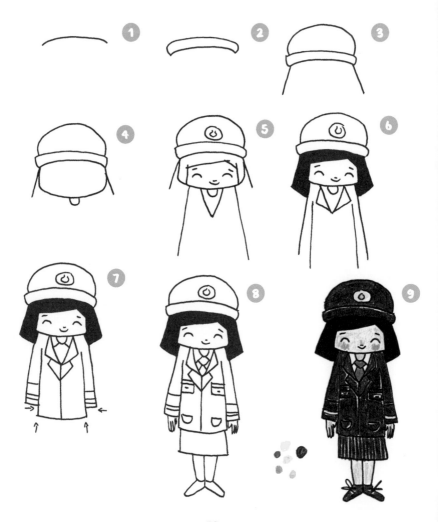

POLICE MASCOT

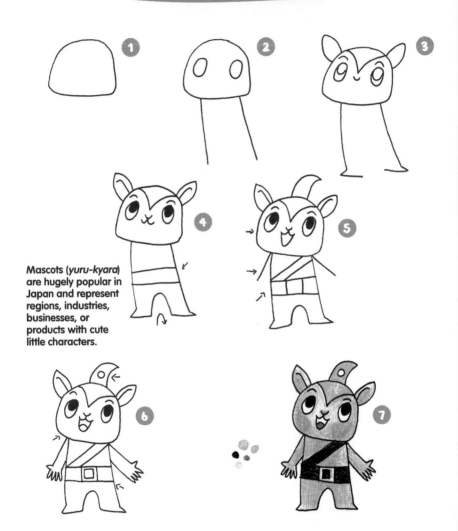

Mascots (*yuru-kyara*) are hugely popular in Japan and represent regions, industries, businesses, or products with cute little characters.

60

OVER TO
YOU!

FIRE MASCOT

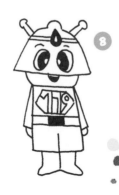
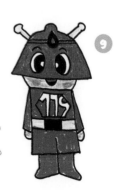

DRAW AND
COLOR!

ELEPHANT MASCOT

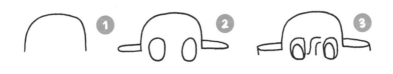

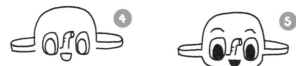

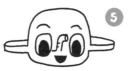

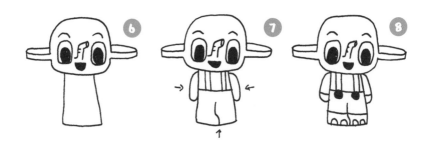

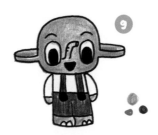

64

YOUR GO!

KODAMA

(FOREST SPIRIT)

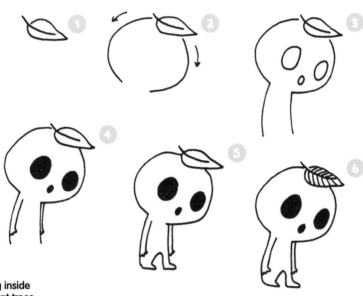

Living inside ancient trees, these spirits roam around the forest, protecting it and keeping nature in balance.

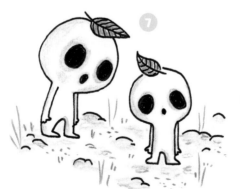

NOW DRAW!

TANUKI YOKAI

(RACCOON DOG SPIRIT)

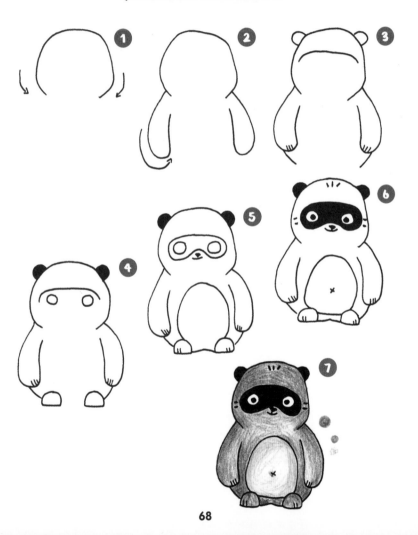

NOW iT'S YOUR TURN...

KASA OBAKE

(UMBRELLA SPIRIT)

Some everyday objects come to life on their one-hundredth birthday, like this cheeky guy!

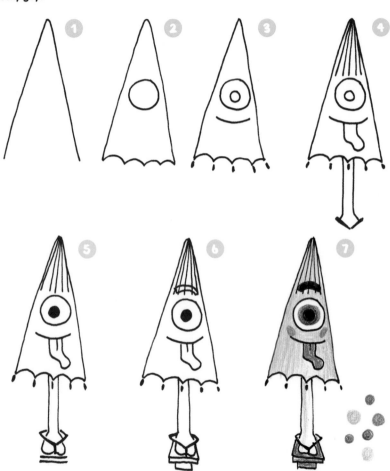

SKETCH iT OUT!

BAKU

(NIGHTMARE EATER)

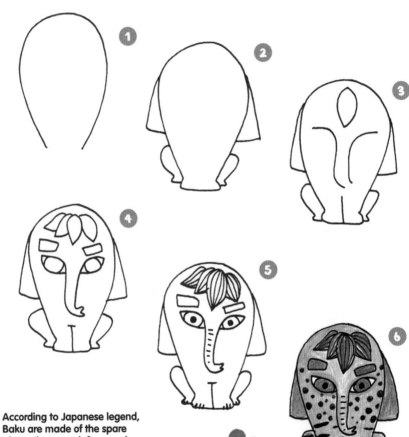

According to Japanese legend, Baku are made of the spare pieces that were left over when the gods had finished creating all the other animals.

PICK UP YOUR
PENCILS!

ZASHIKI WARASHI

(HOUSEHOLD SPIRIT)

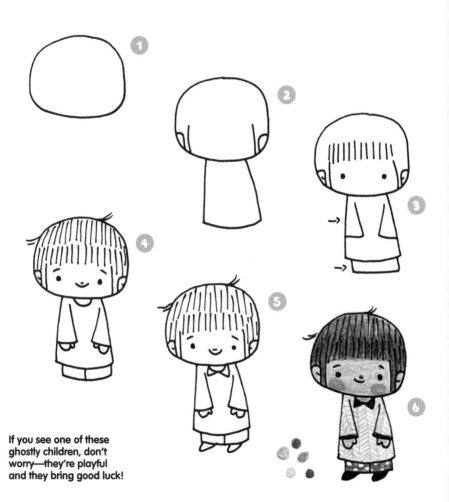

If you see one of these ghostly children, don't worry—they're playful and they bring good luck!

74

BRiNG HiM
TO LiFE...

DARUMA

(TRADITIONAL ZEN DOLL)

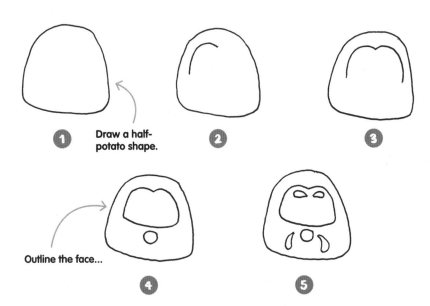

1 Draw a half-potato shape.

2

3

Outline the face...

4

5

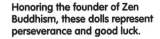

Honoring the founder of Zen Buddhism, these dolls represent perseverance and good luck.

6

...and add expressive features.

7

8

YOUR TURN TO HAVE A GO!

JiZO

(GUARDIAN SPIRITS)

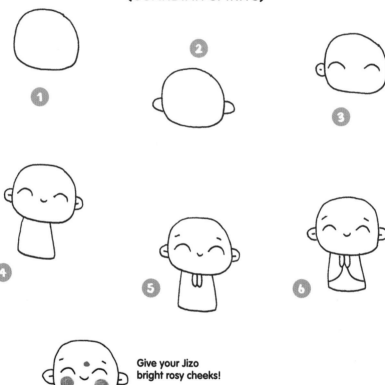

Give your Jizo
bright rosy cheeks!

Always dressed in red, kind Jizo spirits
protect children and travelers.

NOW YOU
DRAW ONE!

Nature

HAMSTER

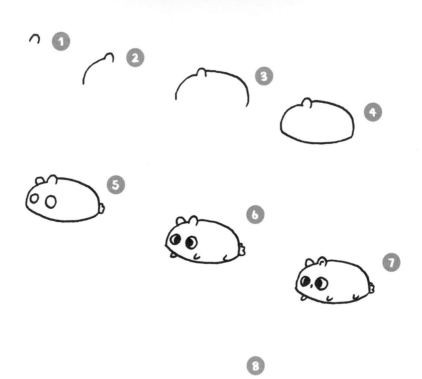

SKETCH YOUR
NEW PET!

FUGU FISH

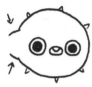

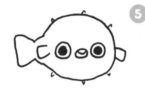

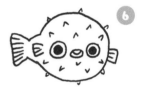

This highly poisonous fish is a delicacy in Japan and chefs must have extensive training before they are allowed to prepare it in special fugu restaurants.

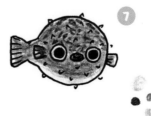

84

OVER TO YOU!

OWL

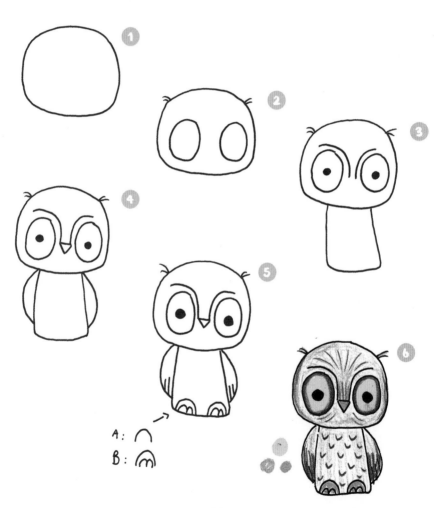

A: ⌒

B: ⌒

86

NOW DRAW
YOURS!

BLACKBIRD

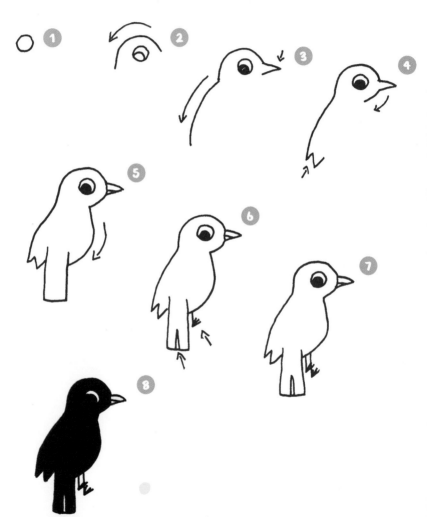

DEER

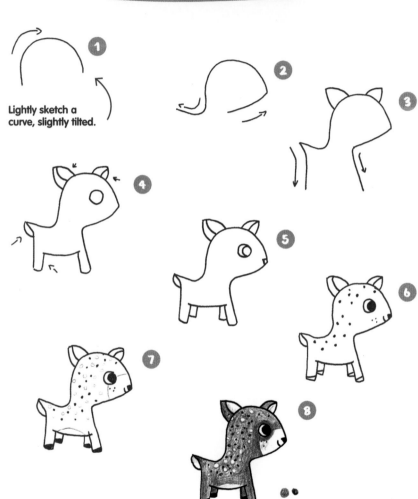

Lightly sketch a curve, slightly tilted.

90

CAT

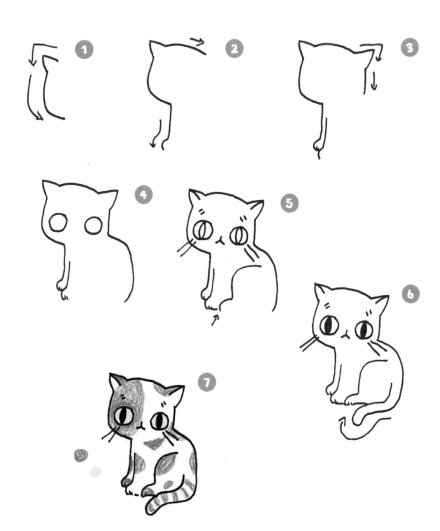

CREATE A
KITTY!

GRASSHOPPER

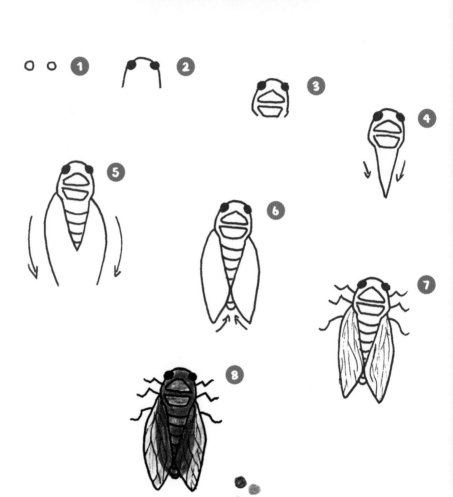

GO ON,
TRY iT!

PUPPY

1

2

3

4

5

6

7

8

9

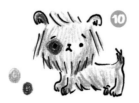

10

MAKE iT CUTE!

SHIBA INU

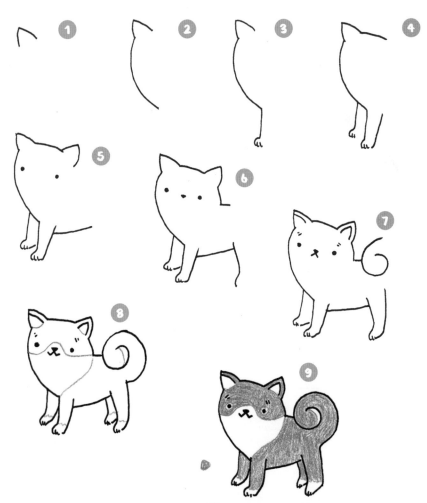

NOW iT'S YOUR
TURN!

DRAGONFLY

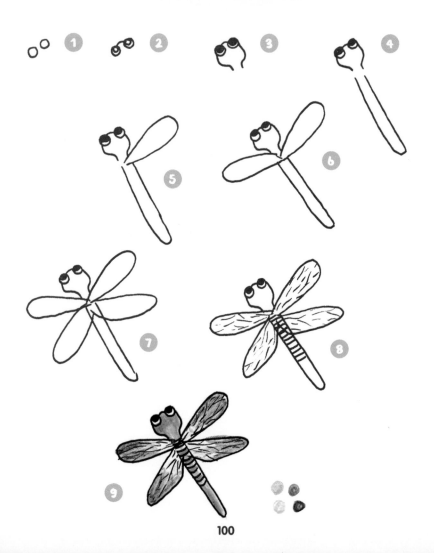

100

TRY iT!

CRANE

102

PENCILS
READY...

SQUID

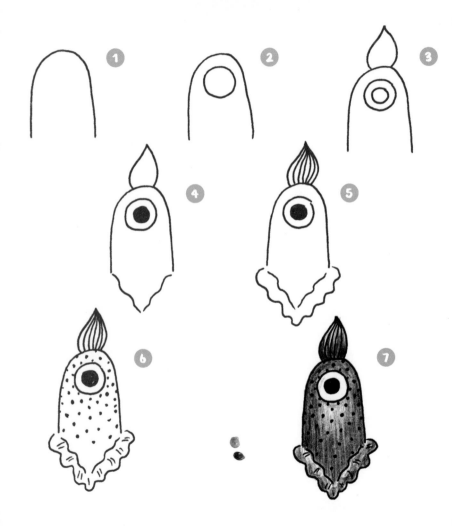

DRAW AND
COLOR...

OCTOPUS

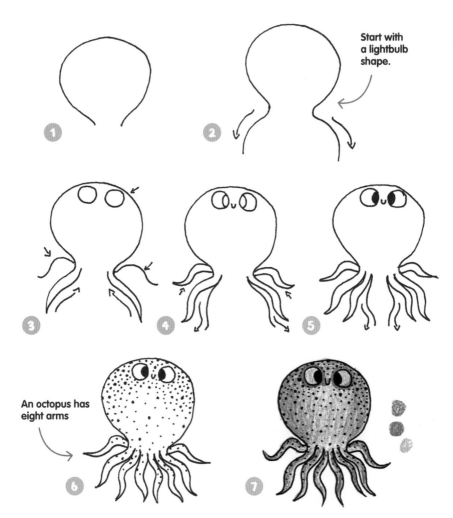

Start with a lightbulb shape.

An octopus has eight arms

iT'S YOUR
TURN!

FOX

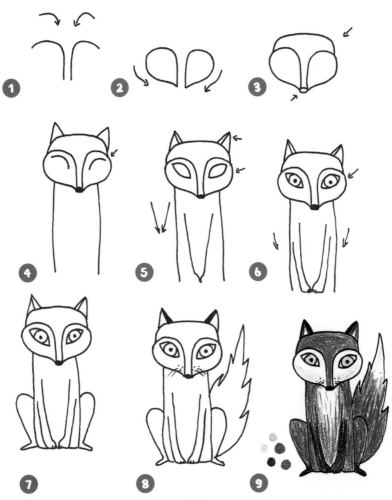

GET TO WORK!

MACAQUE

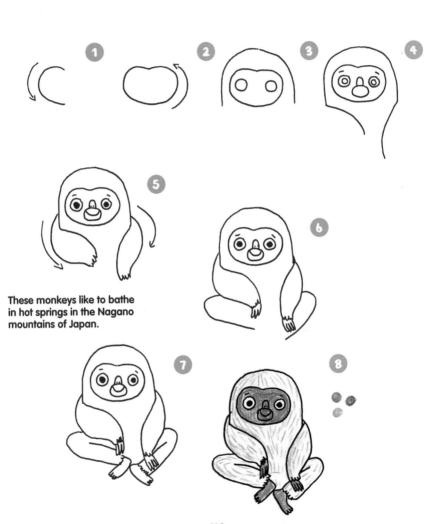

These monkeys like to bathe in hot springs in the Nagano mountains of Japan.

NOW YOU TRY!

PANDA

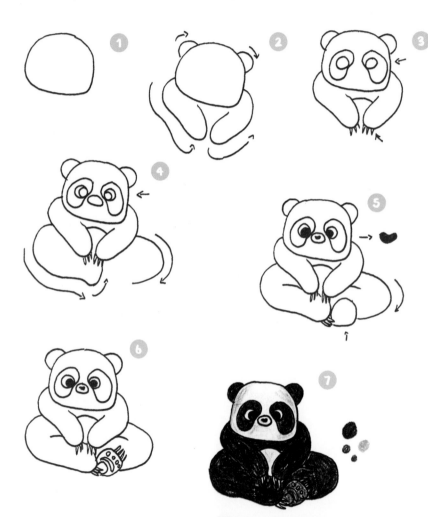

NOW YOU
DO iT!

GiNKGO & OAK LEAVES

GiNKGO LEAF

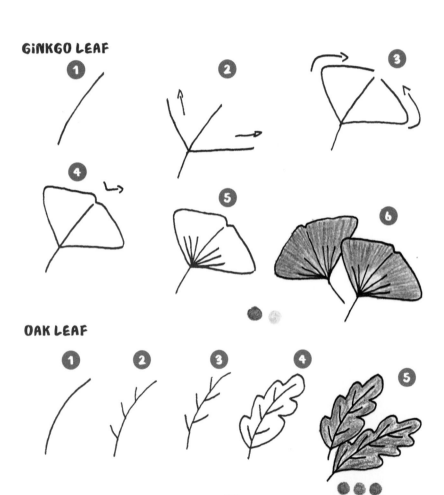

OAK LEAF

NOW TRY FOR YOURSELF!

MAPLE LEAF

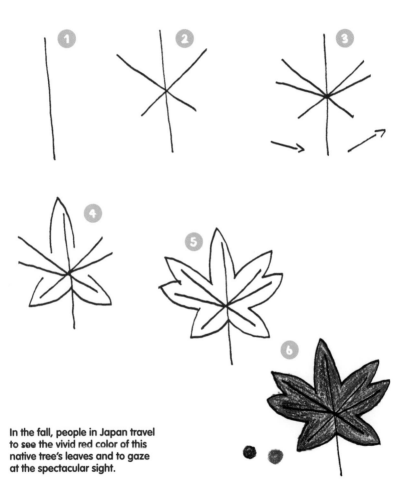

In the fall, people in Japan travel to see the vivid red color of this native tree's leaves and to gaze at the spectacular sight.

PICK UP YOUR
PENCIL!

POT PLANT 1

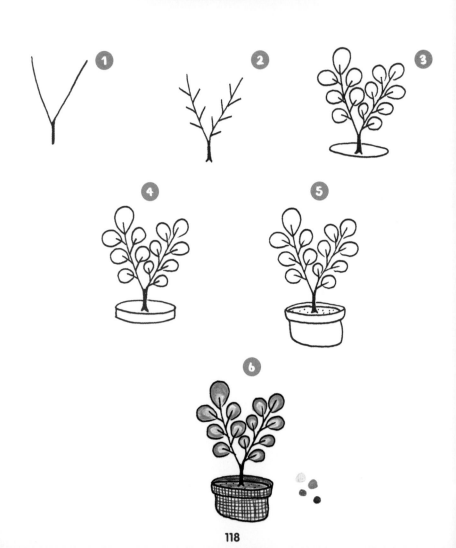

SEE HOW
EASY iT iS!

POT PLANT 2

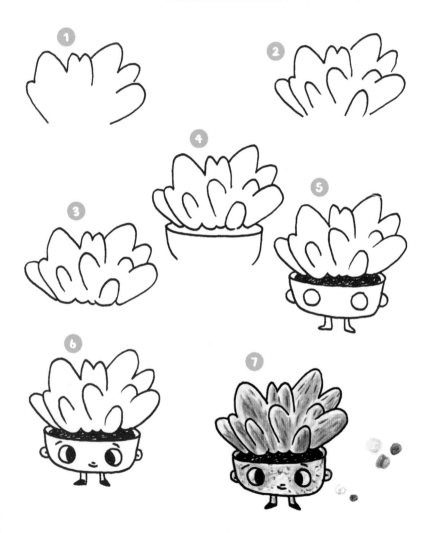

NOW DRAW!

POT PLANT 3

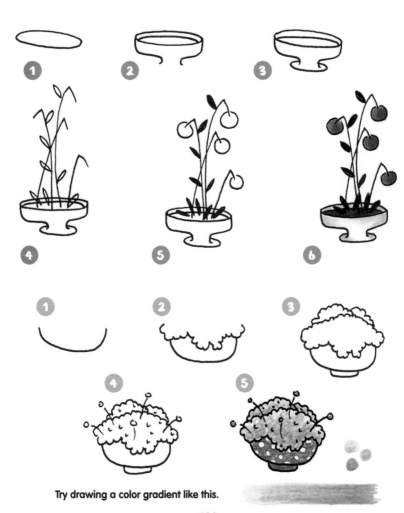

Try drawing a color gradient like this.

GET SKETCHING!

PEACEFUL GARDEN

First sketch the
shapes of the plants.

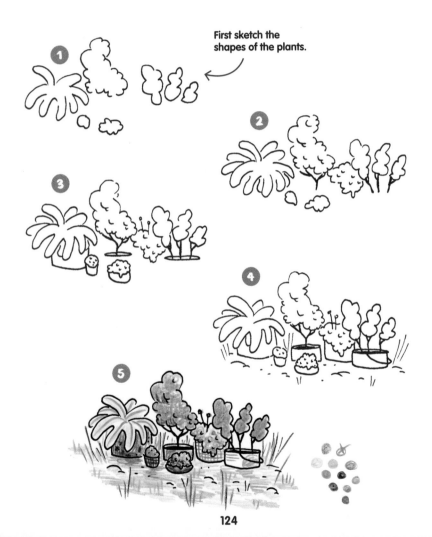

NOW DRAW
YOURS!

LIVELY GARDEN

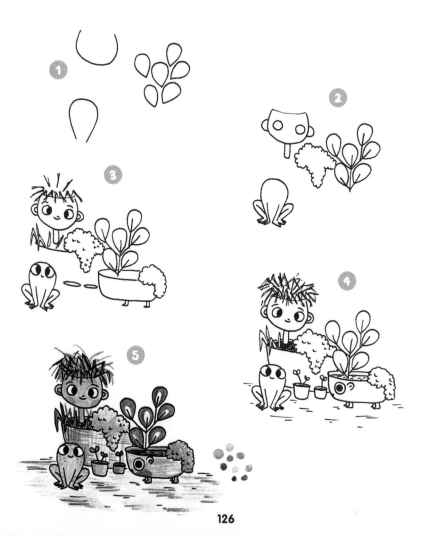

IT'S PENCIL TIME!

TREE 1

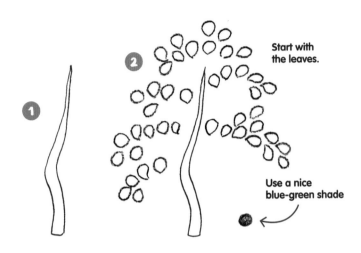

Start with the leaves.

Use a nice blue-green shade

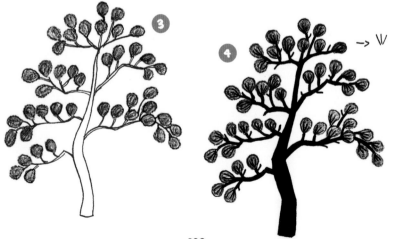

128

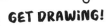
GET DRAWING!

TREE 2

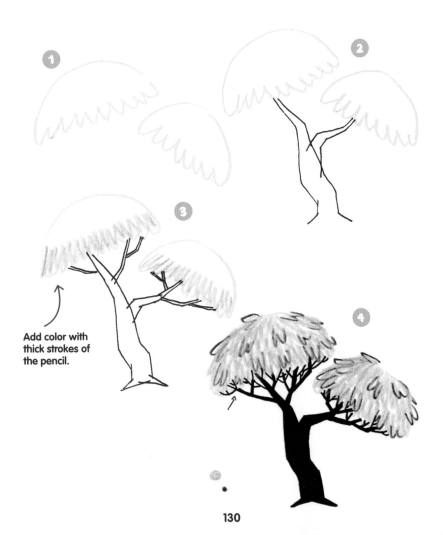

Add color with thick strokes of the pencil.

130

SHARPEN YOUR PENCILS!

TREE 3

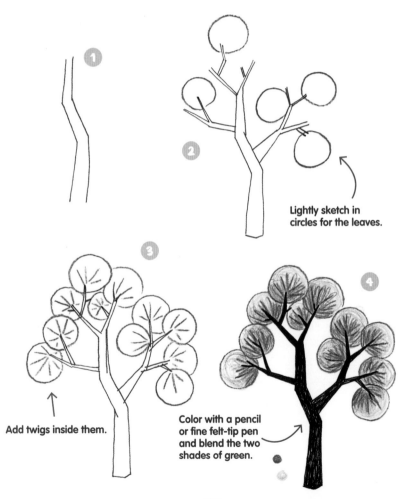

Lightly sketch in circles for the leaves.

Add twigs inside them.

Color with a pencil or fine felt-tip pen and blend the two shades of green.

132

LET'S DO THIS!

TREE 4

1

2

Use two shades of
yellow: one light
and the other more
intense. Start with
the lighter one.

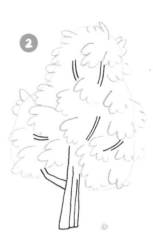

3

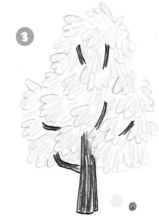

4

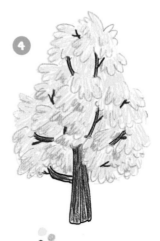

NOW YOU TRY!

TREE 5

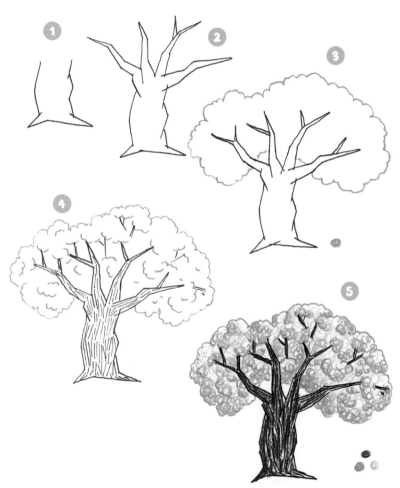

iT'S YOUR GO!

TREE 6

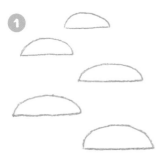

1

These shapes should be smaller at the top and larger at the bottom.

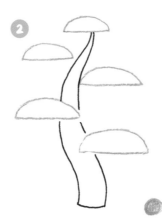

2

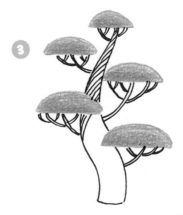

3

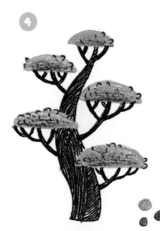

4

138

HAVE A TURN!

TREE 7

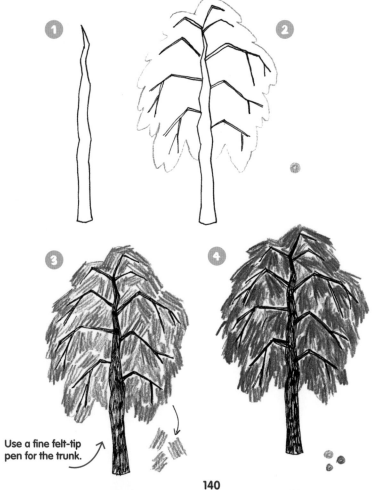

Use a fine felt-tip pen for the trunk.

DRAW AND
COLOR!

Food

FRUIT

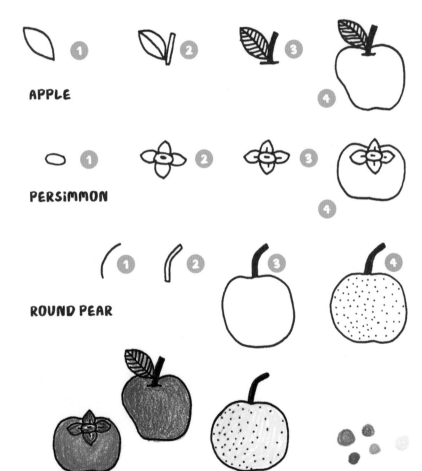

APPLE

PERSIMMON

ROUND PEAR

NOW DRAW
SOME FRUIT!

DANGO

(SWEET RICE DUMPLINGS)

146

YOUR TURN!

NiGiRi SUSHi

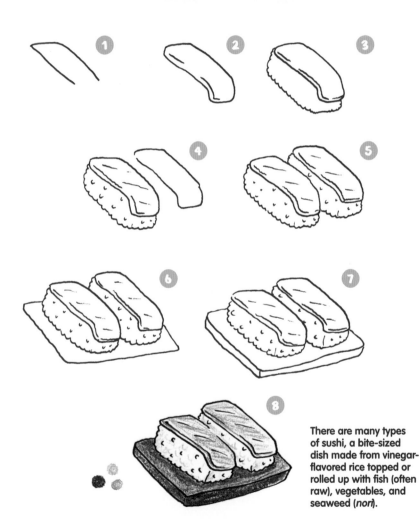

There are many types of sushi, a bite-sized dish made from vinegar-flavored rice topped or rolled up with fish (often raw), vegetables, and seaweed (*nori*).

NOW MAKE YOUR OWN!

RAMEN

(JAPANESE NOODLE SOUP)

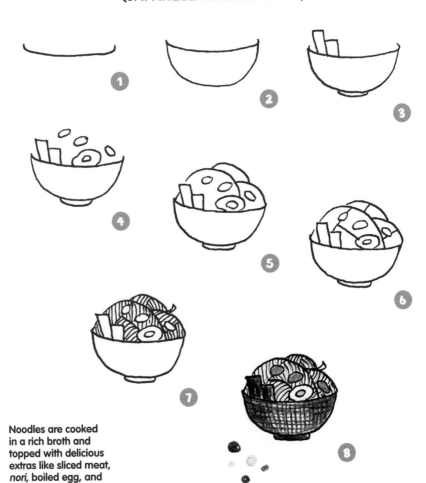

Noodles are cooked in a rich broth and topped with delicious extras like sliced meat, *nori*, boiled egg, and bamboo shoots.

¡T'S YOUR GO!

MUSHROOMS

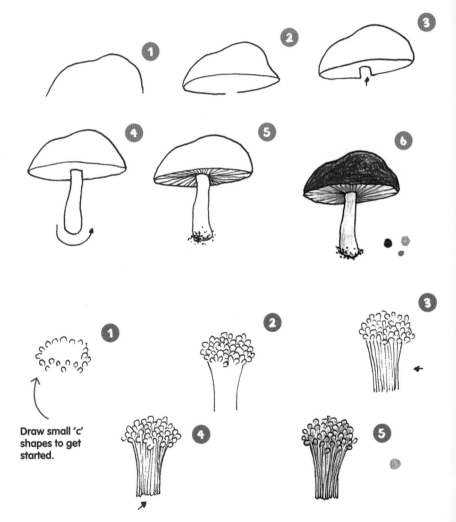

Draw small 'c'
shapes to get
started.

152

NOW iT'S
YOUR TURN!

DAIKON

(WHITE RADISH)

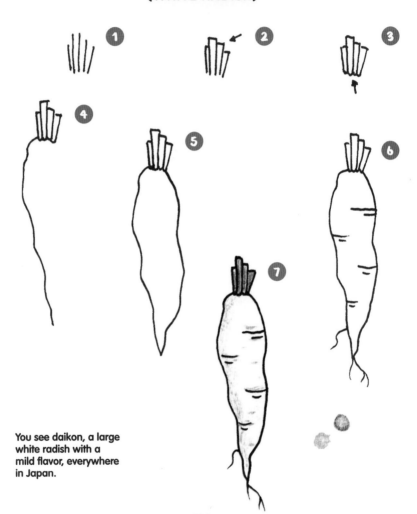

You see daikon, a large white radish with a mild flavor, everywhere in Japan.

LET'S SEE HOW YOU DO!

ONIGIRI

(RICE BALLS)

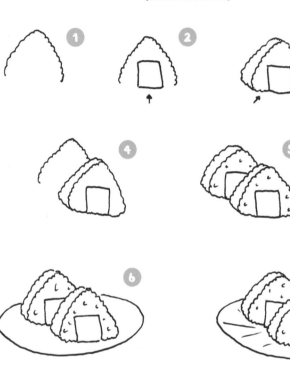

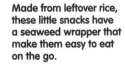

Made from leftover rice, these little snacks have a seaweed wrapper that make them easy to eat on the go.

MMM, TASTY!

EDAMAME & NARUTOMAKi

(GREEN SOY BEANS / FISH PASTE SLICES)

EDAMAME

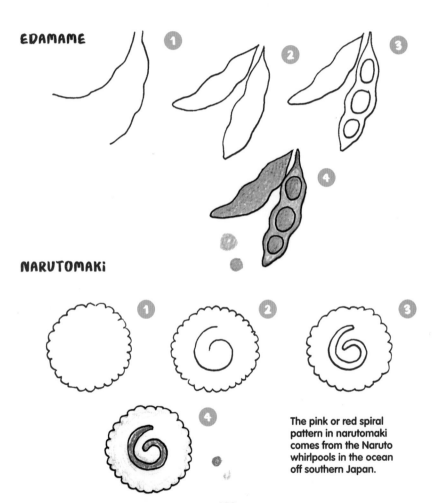

NARUTOMAKi

The pink or red spiral pattern in narutomaki comes from the Naruto whirlpools in the ocean off southern Japan.

YOUR TURN!

SHRIMP

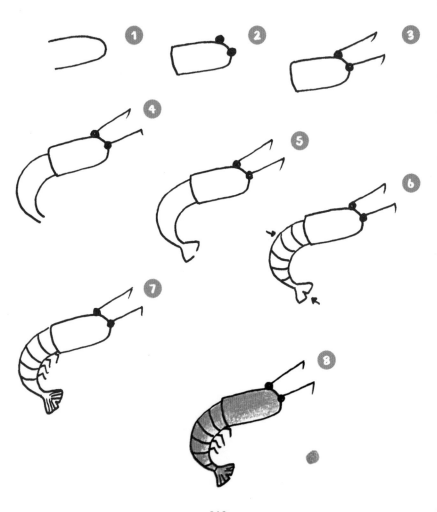

GO ON,
DRAW ONE!

MAKI SUSHI

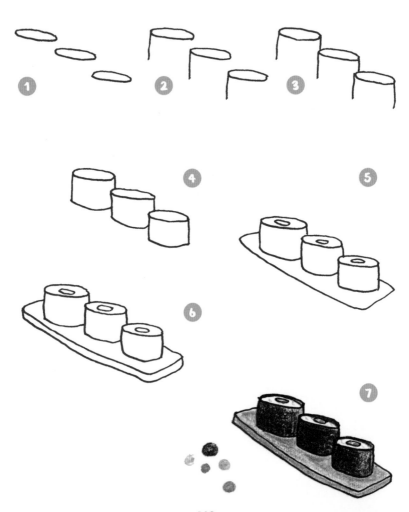

CREATE AND COLOR!

LOTUS ROOT

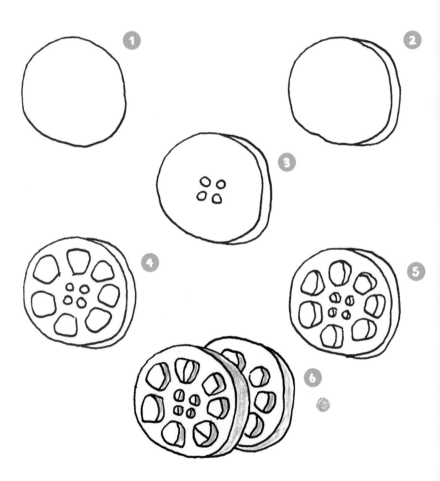

164

PENCILS READY!

CHOPSTICKS, RICE, & TEA

CHOPSTICKS IN A PACKET

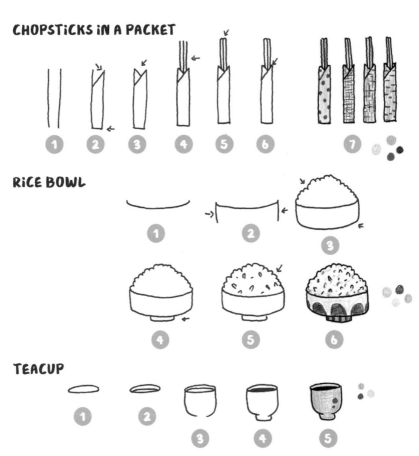

RICE BOWL

TEACUP

NOW YOU TRY!

KITCHEN UTENSILS

CHOPSTICKS ON A STAND

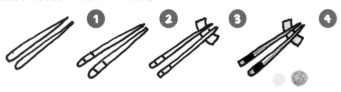

THERMOS

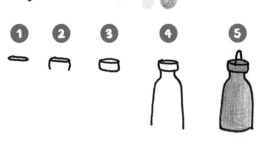

RICE COOKER

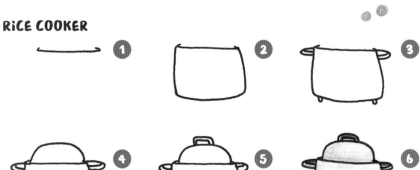

GET DRAWING!

Sights

SMALL HOUSE

1 Gently sketch the shape of the building in light pencil. Don't press too hard!

2 Go over the lines with a fine black felt-tip pen. Don't do the base of the wall yet.

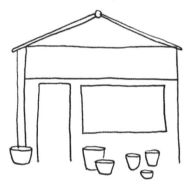

3 Add detail. Some objects in front will bring the house to life.

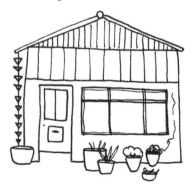

4 Then add some color. Remember to add the light shades first.

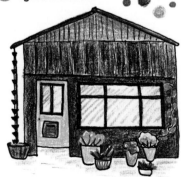

CAN YOU
DRAW iT?

CITY HOUSE

1 Lightly sketch the outline of the building.

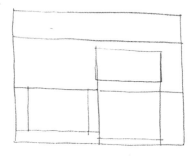

2 Go over the main lines with a black felt-tip pen, and erase some of the guidelines.

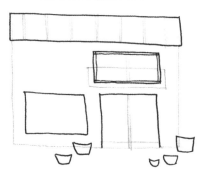

3 Add some detail to bring the scene to life.

4 Now color in, adding light tones before dark.

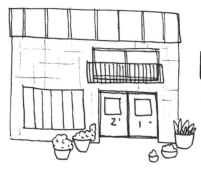

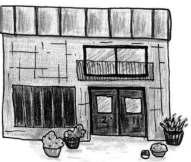

LET'S GO!

NARROW HOUSE

1 Sketch the shape of the building in light pencil. Don't press too hard.

2 Go over the main lines with a black felt-tip pen, and erase some of the guidelines.

3 Add some detail to bring the scene to life.

4 Color it in, adding lighter tones before the darker ones.

BASIC STOREFRONT

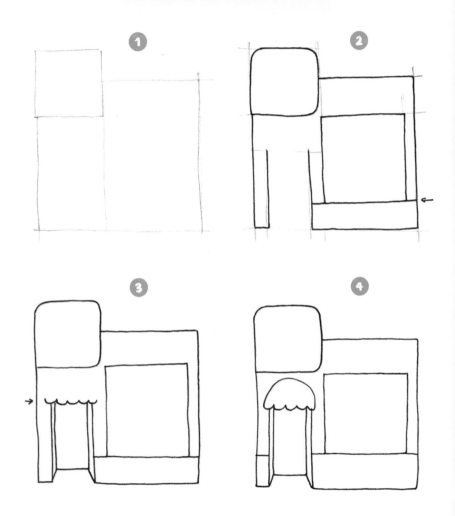

Start with a square
and two rectangles.

Use this guide to help
you get started. On the
following pages you'll find
some ideas to bring your
stores to life.

BAKERY

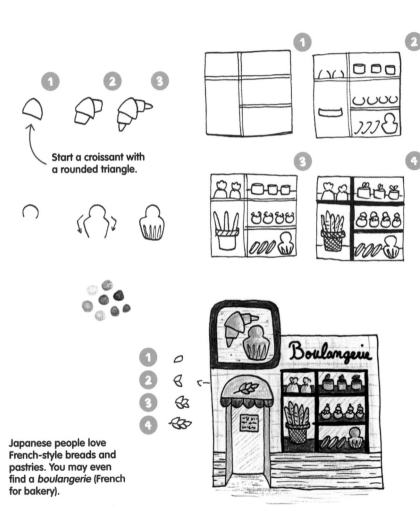

Start a croissant with a rounded triangle.

Japanese people love French-style breads and pastries. You may even find a *boulangerie* (French for bakery).

Boulangerie

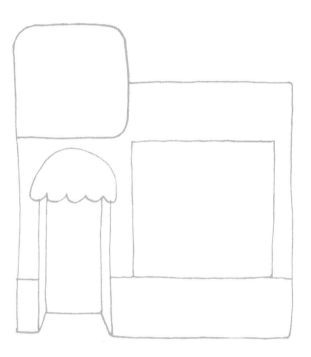

BOOKSTORE

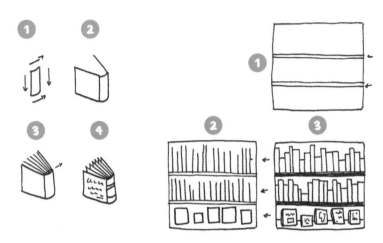

You can write the name of your store or draw a picture on the sign.

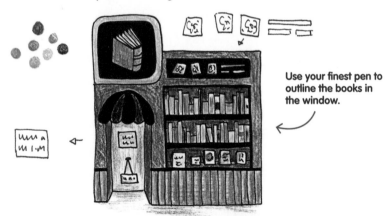

Use your finest pen to outline the books in the window.

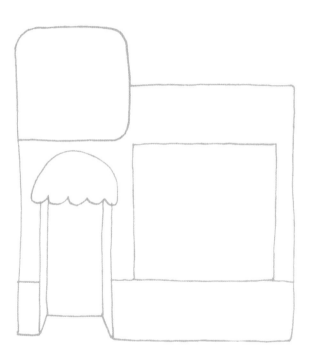

SOCK SHOP

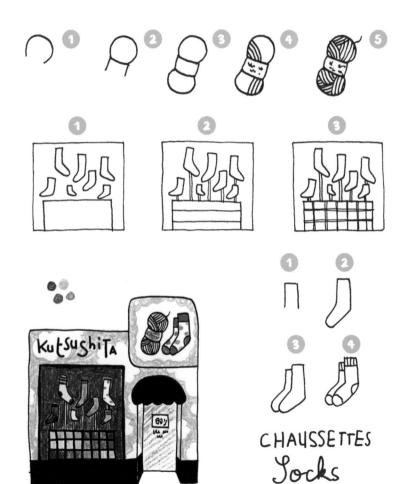

CHAUSSETTES
Socks
KUTSUSHITAYA

184

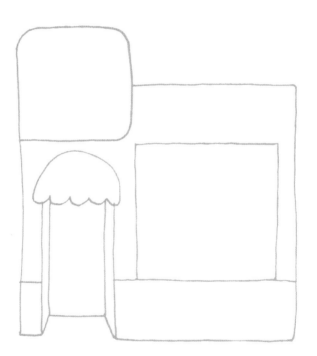

CITY STOREFRONT

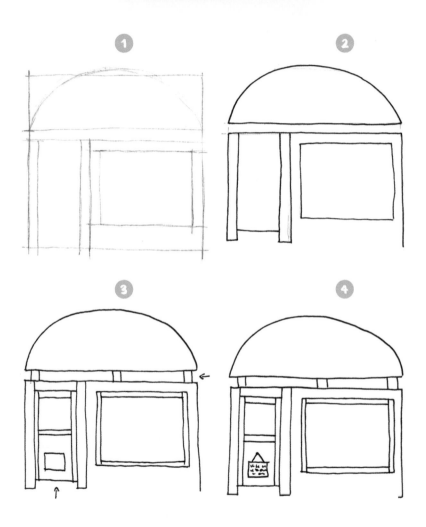

TRY iT!

Use these sketched lines to create a basic storefront.

On the following pages you'll find some ideas for bringing the store to life.

TEAROOM

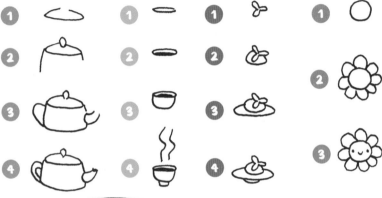

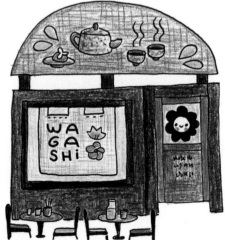

Wagashi are traditional sweet treats, that are served with green tea, for example *mochi*, soft rice cakes with a sweet filling and *dango*, steamed dumplings with a sticky sauce.

FLORIST

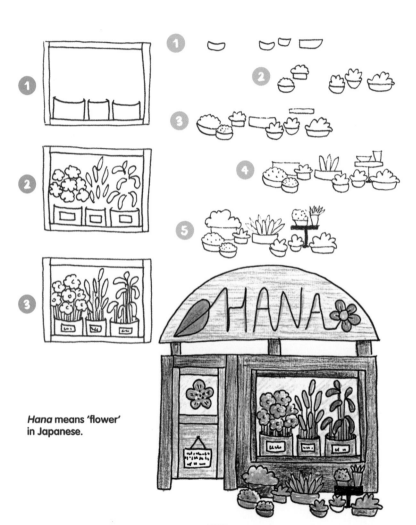

Hana means 'flower' in Japanese.

190

NOW iT'S YOUR TURN...

COMBINI

(CONVENIENCE STORE)

A neighborhood store where you can find everything you need at any time of day or night.

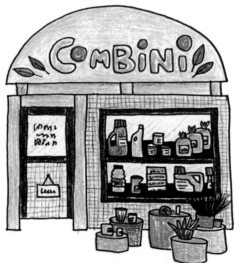

1

2

3

4

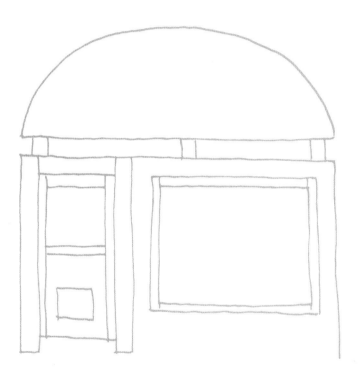

MIYAJIMA GATE

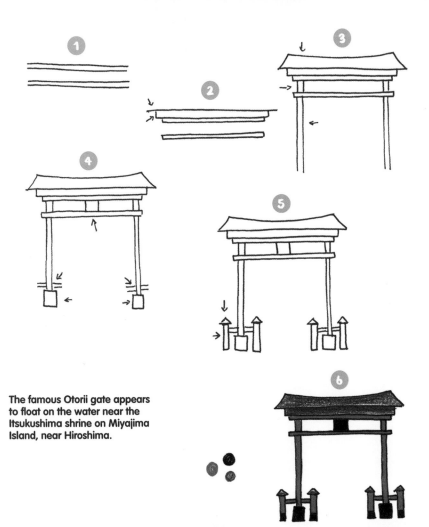

The famous Otorii gate appears to float on the water near the Itsukushima shrine on Miyajima Island, near Hiroshima.

Use this guide
to get started.

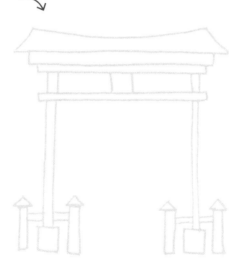

MOUNT FUJI

An iconic landmark of Japan, this active volcano last erupted in 1707 and is the country's highest peak at 12,400 ft (3776m).

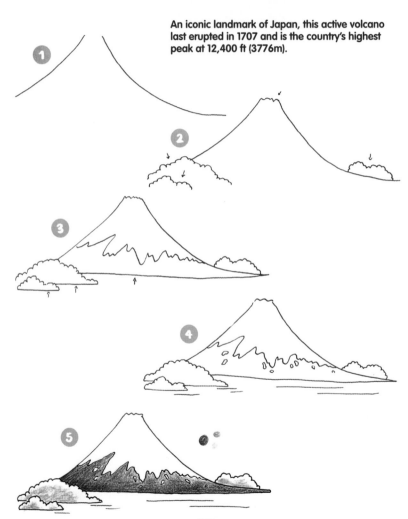

TRY FOR YOURSELF!

TOKYO SKYTREE

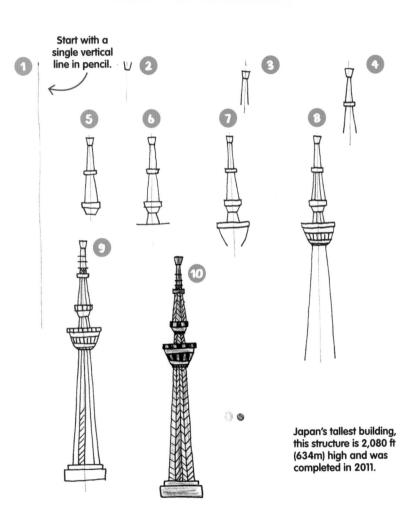

Start with a single vertical line in pencil.

1 2 3 4
5 6 7 8
9 10

Japan's tallest building, this structure is 2,080 ft (634m) high and was completed in 2011.

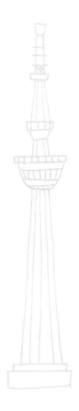

KUSAMA'S PUMPKINS

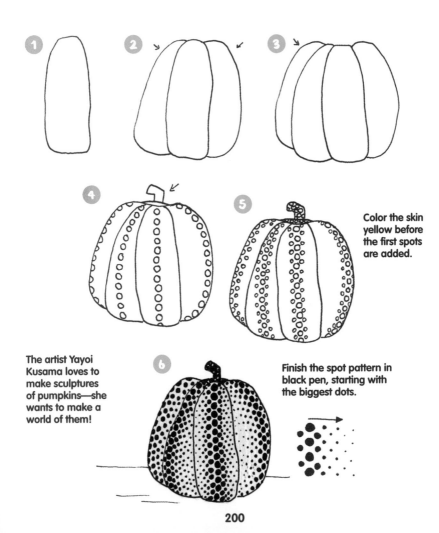

Color the skin yellow before the first spots are added.

The artist Yayoi Kusama loves to make sculptures of pumpkins—she wants to make a world of them!

Finish the spot pattern in black pen, starting with the biggest dots.

NOW DRAW
A PUMPKIN!

GOLDEN PAVILION

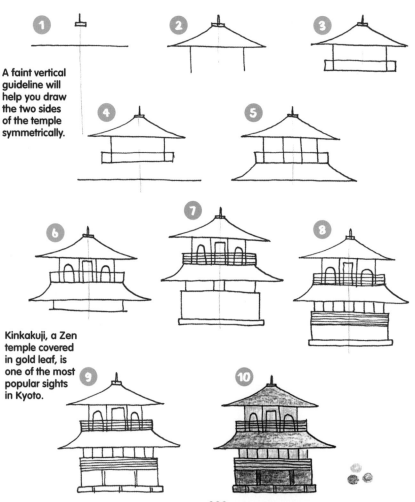

A faint vertical guideline will help you draw the two sides of the temple symmetrically.

Kinkakuji, a Zen temple covered in gold leaf, is one of the most popular sights in Kyoto.

Use these guidelines to
create your own temple!

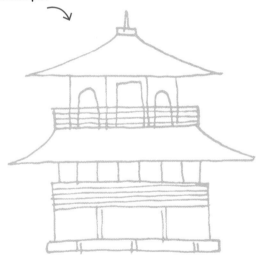

TOKYO TOWER

Built in 1958 and based on Paris' Eiffel Tower,
the Tokyo version stands at 1,092 ft (333m) high.

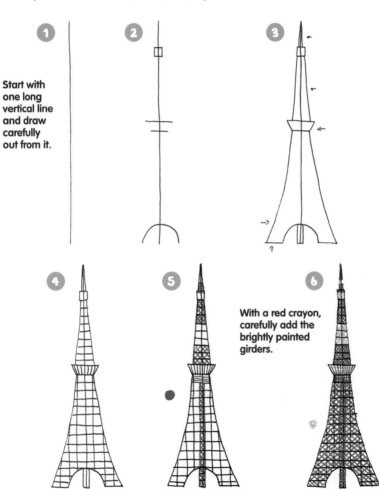

Start with one long vertical line and draw carefully out from it.

With a red crayon, carefully add the brightly painted girders.

LET'S GO!

KAMAKURA BUDDHA

1

In pencil, draw the shapes, taking care with the proportions.

2

Add lines for the hairline and arms.

Base

3

Add the ears and the robe's neckline.

4

Show the folds of the robe with blue pencil lines.

The Great Buddha of Kamakura is as tall as a five-storey building!

5

DRAW iT
YOURSELF!

Patterns
and textures

ONE-COLOR SHADING

MAKE A COLOR FADE

Press the pencil very gently on the paper...

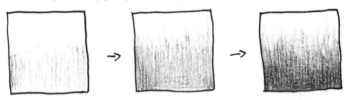

... gradually press harder to make the darker area.

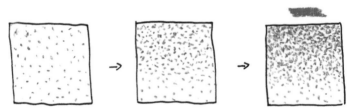

You can shade with tiny dots by making them far apart
for light areas and closer together for a darker effect.

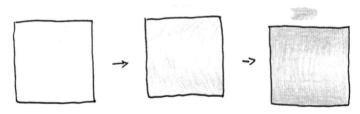

Or try quick, light strokes instead of dots.

CREATE YOUR OWN...

Practice here

TWO-COLOR SHADING

You can blend two crayon shades into each other—start with very gentle
strokes of the pencil. Apply the lighter tone first, then the darker one.

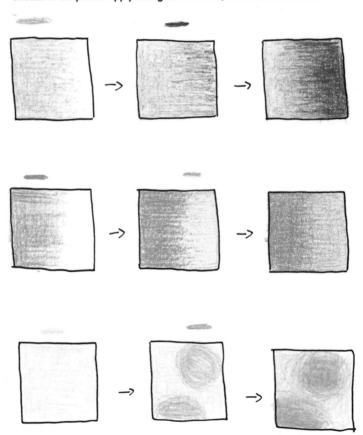

YOU TRY!

Practice here

NATURAL TEXTURES

WOOD

Use colored pencils and always start with the lightest color.

GRASS

This lawn looks much better than a single shade of green.

Practice here

FABRIC TEXTURES

WEAVES

Make beautiful weaves by building up layers of horizontal and vertical lines. Remember to start with the lightest shade.

KNITS

Experiment here

BUILDING TEXTURES

EARTH

WOOD

GLASS BRICKS

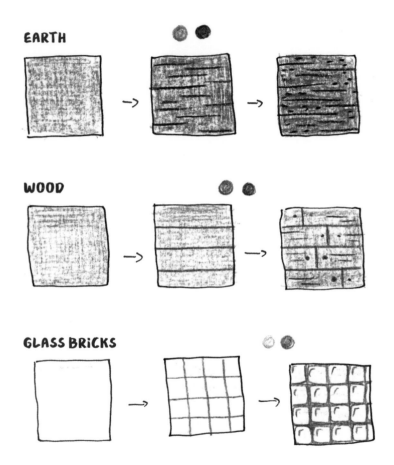

Practice here

CHECKED PATTERNS

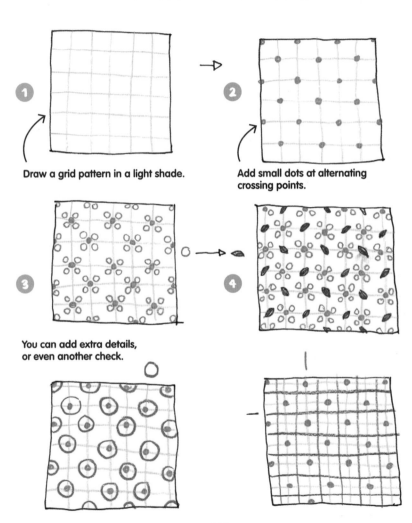

1 Draw a grid pattern in a light shade.

2 Add small dots at alternating crossing points.

3 You can add extra details, or even another check.

4

GO PATTERN
CRAZY!

LINE PATTERNS

1

Draw some broken lines.

2

Add little circles to the lines,...

...some multi-colored spots,...

...a check pattern,...

...little horizontal stripes,...

...or a checkerboard.

PLAY AROUND
HERE!

PICTURE PATTERNS

Fill in the background with a pale shade... and then add fun kawaii details!

WAVE PATTERN

Create this classic Japanese pattern
of waves with simple curved lines.

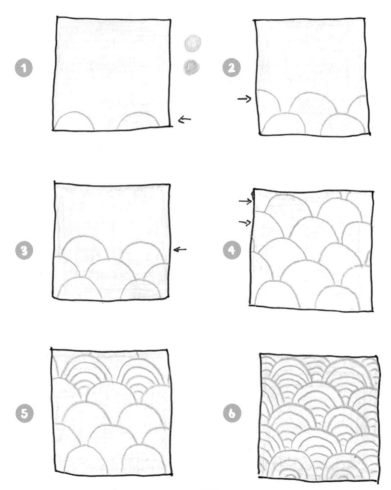

iNSPiRATiON

Look at these pages for ideas of how to combine your own drawings and create unique items such as bookmarks, greetings cards, and artworks.

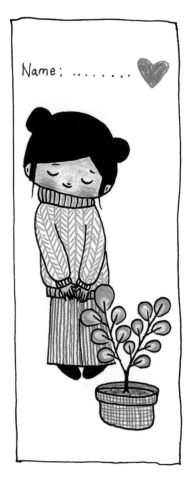

Name:

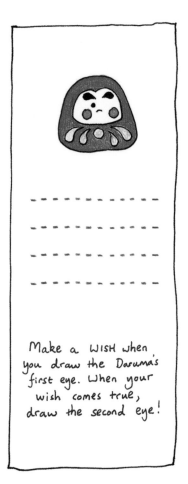

Make a WISH when you draw the Daruma's first eye. When your wish comes true, draw the second eye!

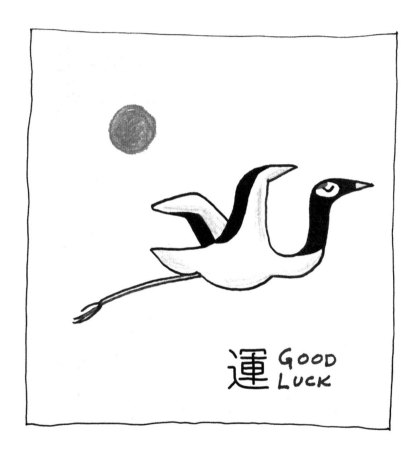

運 GOOD LUCK

SWEET
DREAMS

grandma

green fingers

grandpa

Name:

232

CONGRATULATIONS

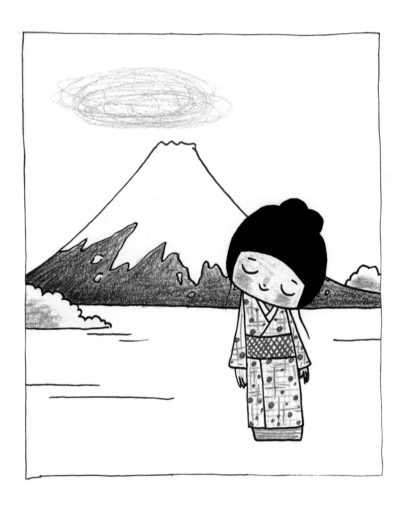

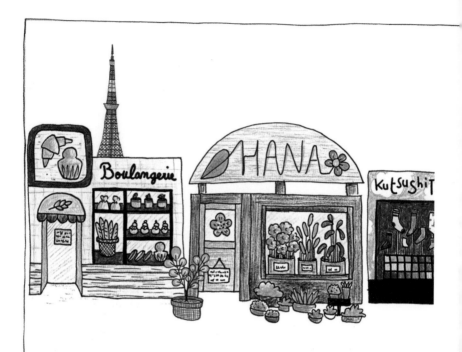

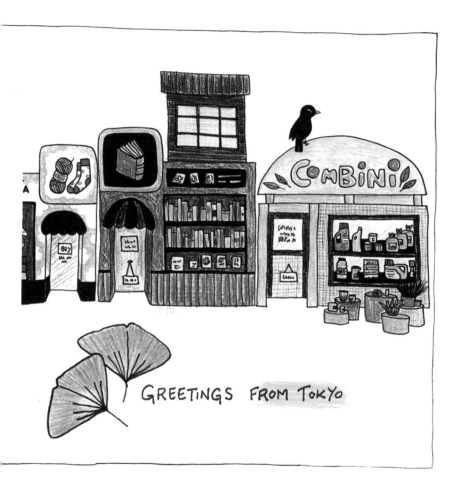

GREETINGS FROM TOKYO

This book is dedicated to Pascale Caron.

First published in the United Kingdom in 2024 by Skittledog, an imprint of
Thames & Hudson Ltd, 181A High Holborn, London WC1V 7QX
Translated from the French by Roly Allen

Original edition *J'apprends à dessiner le Japon kawaii* © 2024 Hachette Livre (Marabout)
This edition © 2024 Thames & Hudson Ltd, London

ISBN 978-1-837-76040-4

Printed and bound in China
skittledog.com